*Zencircles, Lotuses, and Crescent Moons:*
*A Calming Coloring Book*

*C. Hailyn*

Copyright © 2016 by C. Hailyn

All rights reserved. No part of this book may be reproduced in any form without written permission from the publisher.

ISBN 978-1-365-45763-0

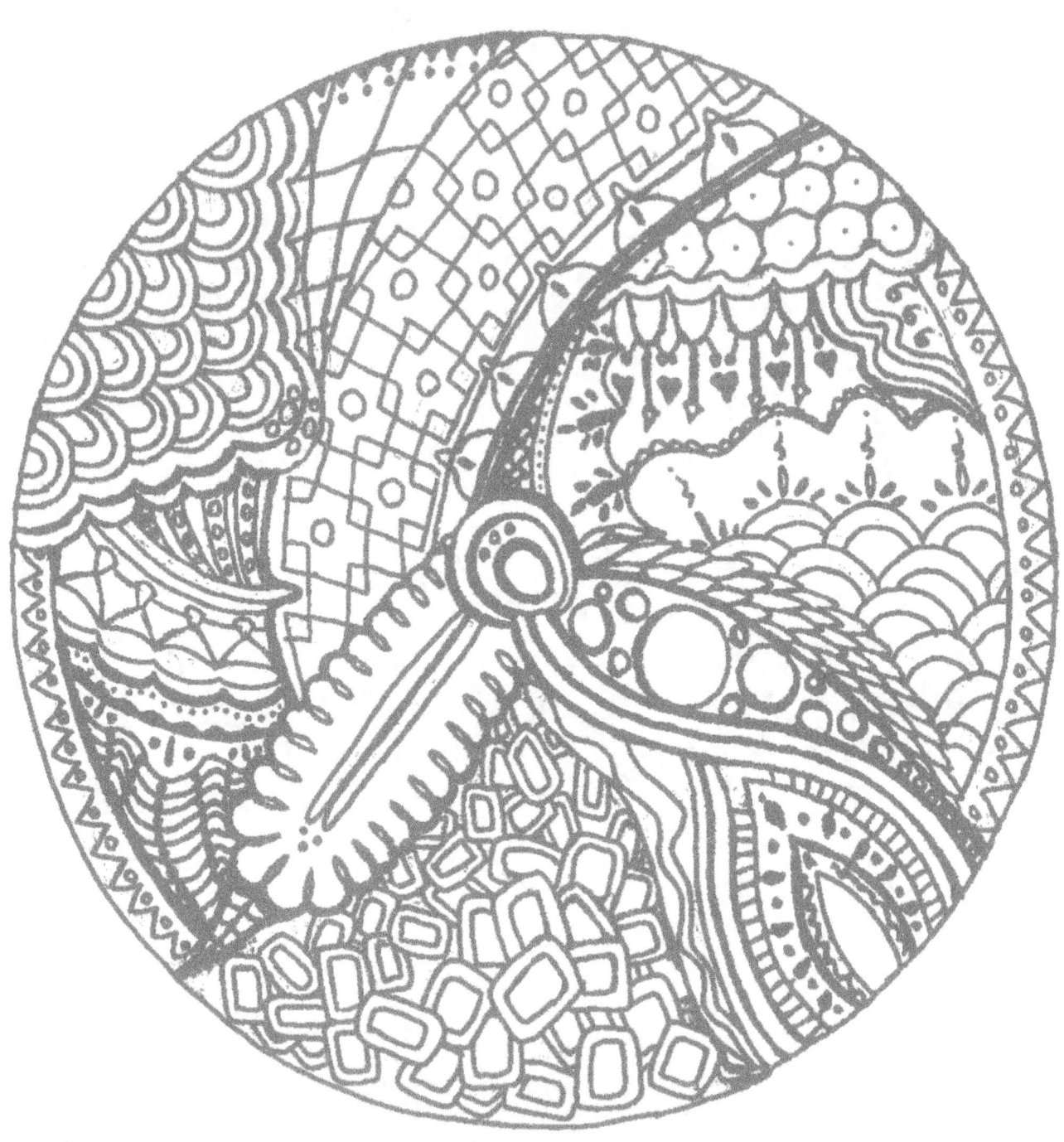

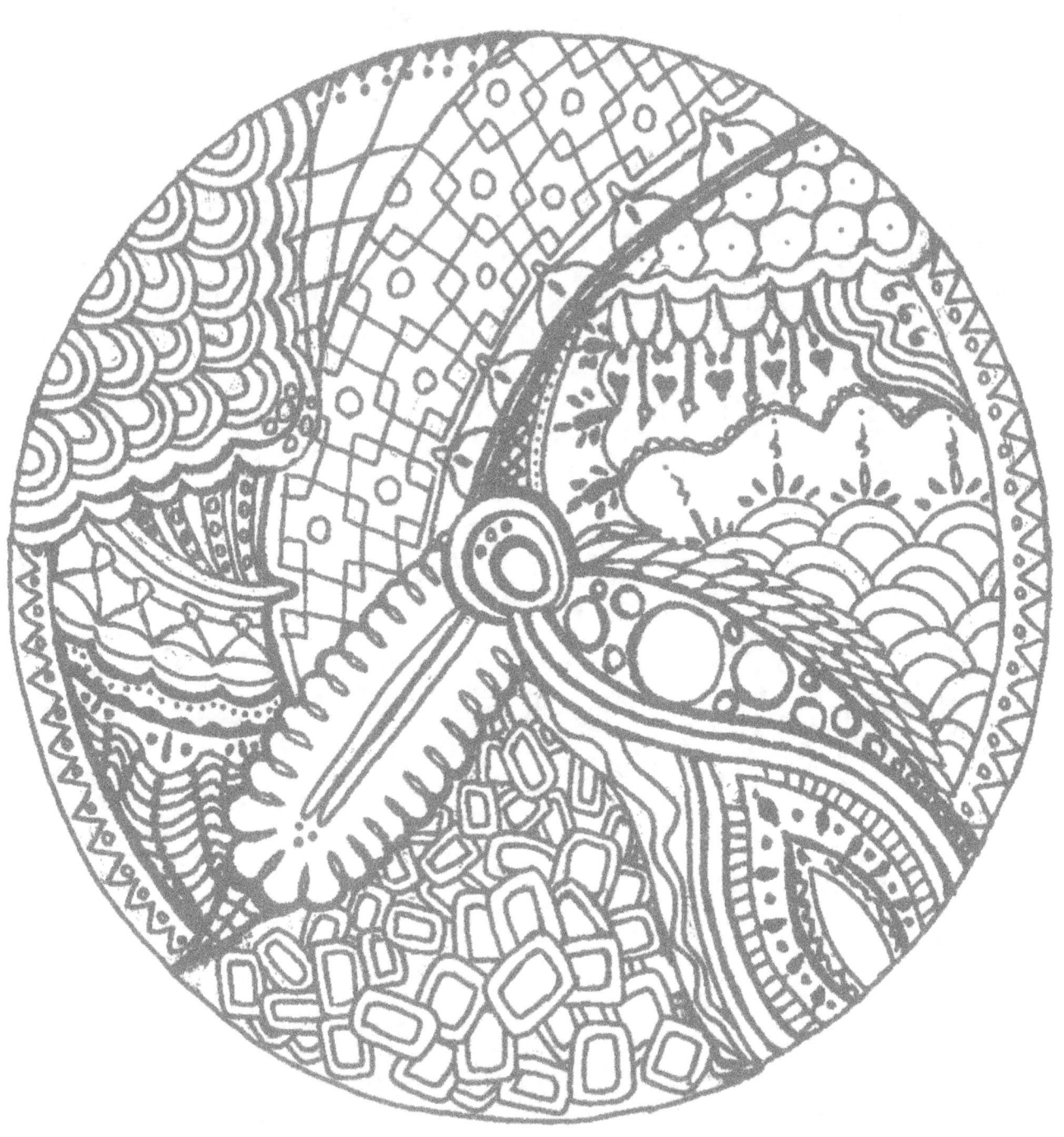

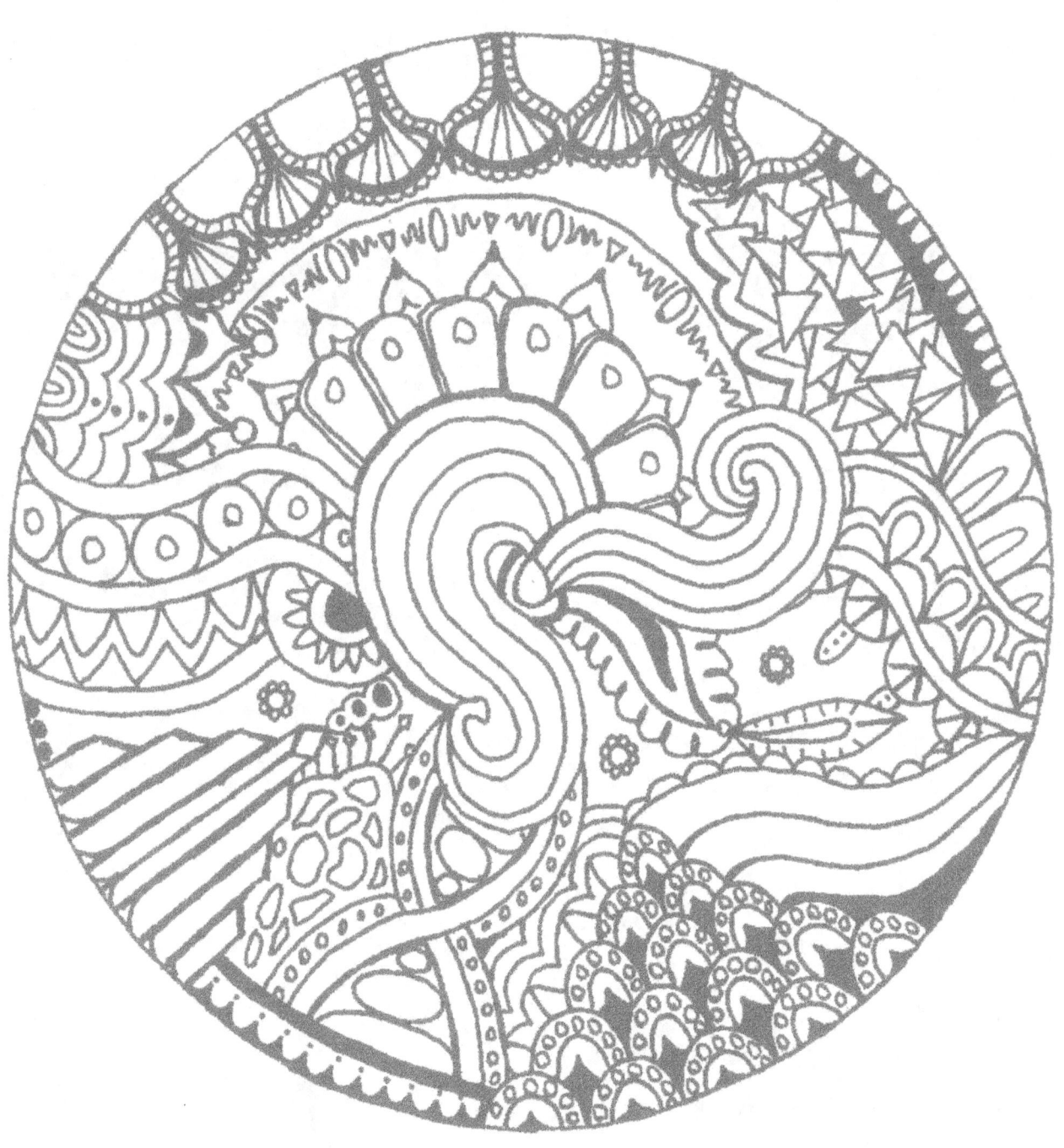

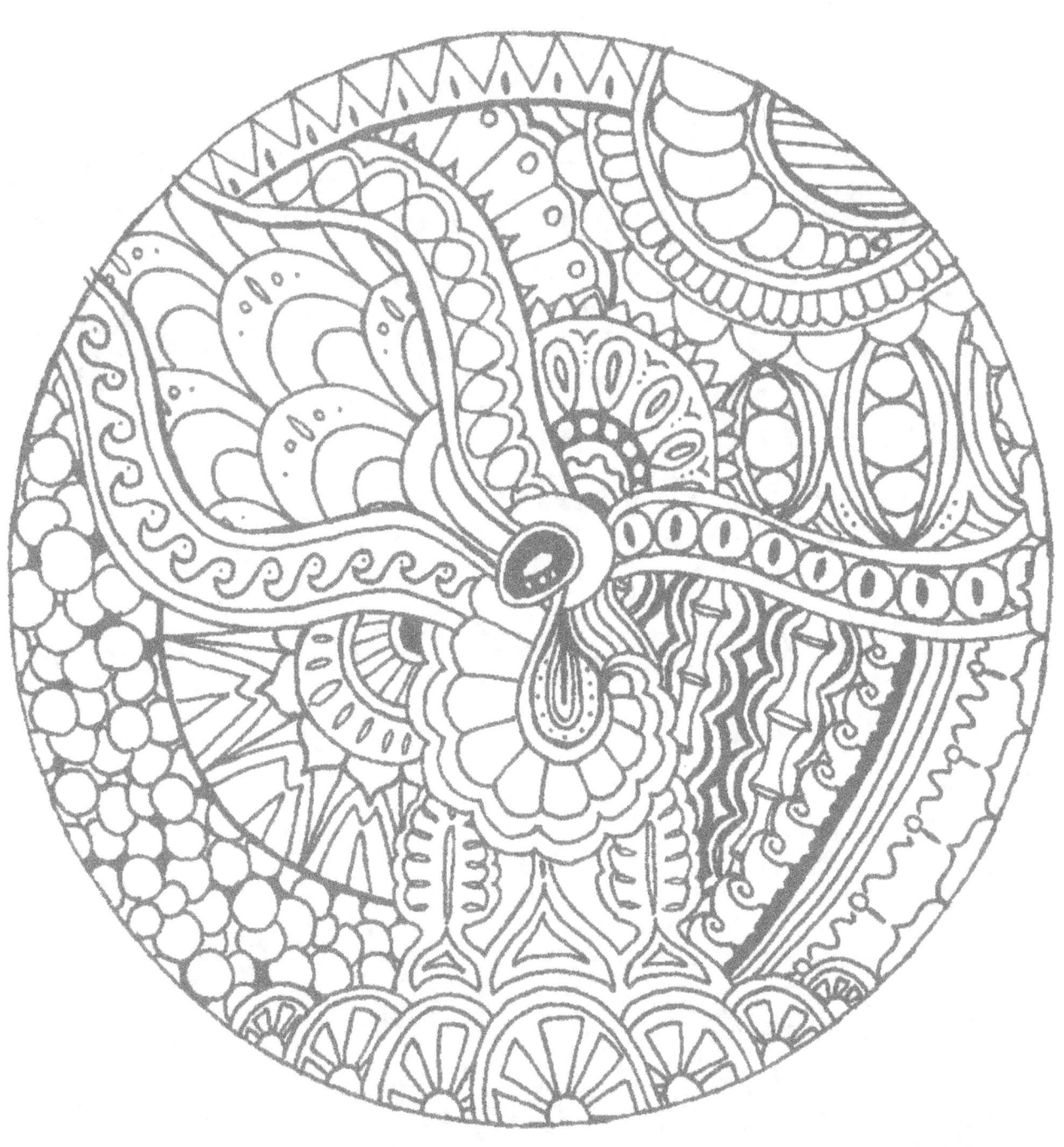

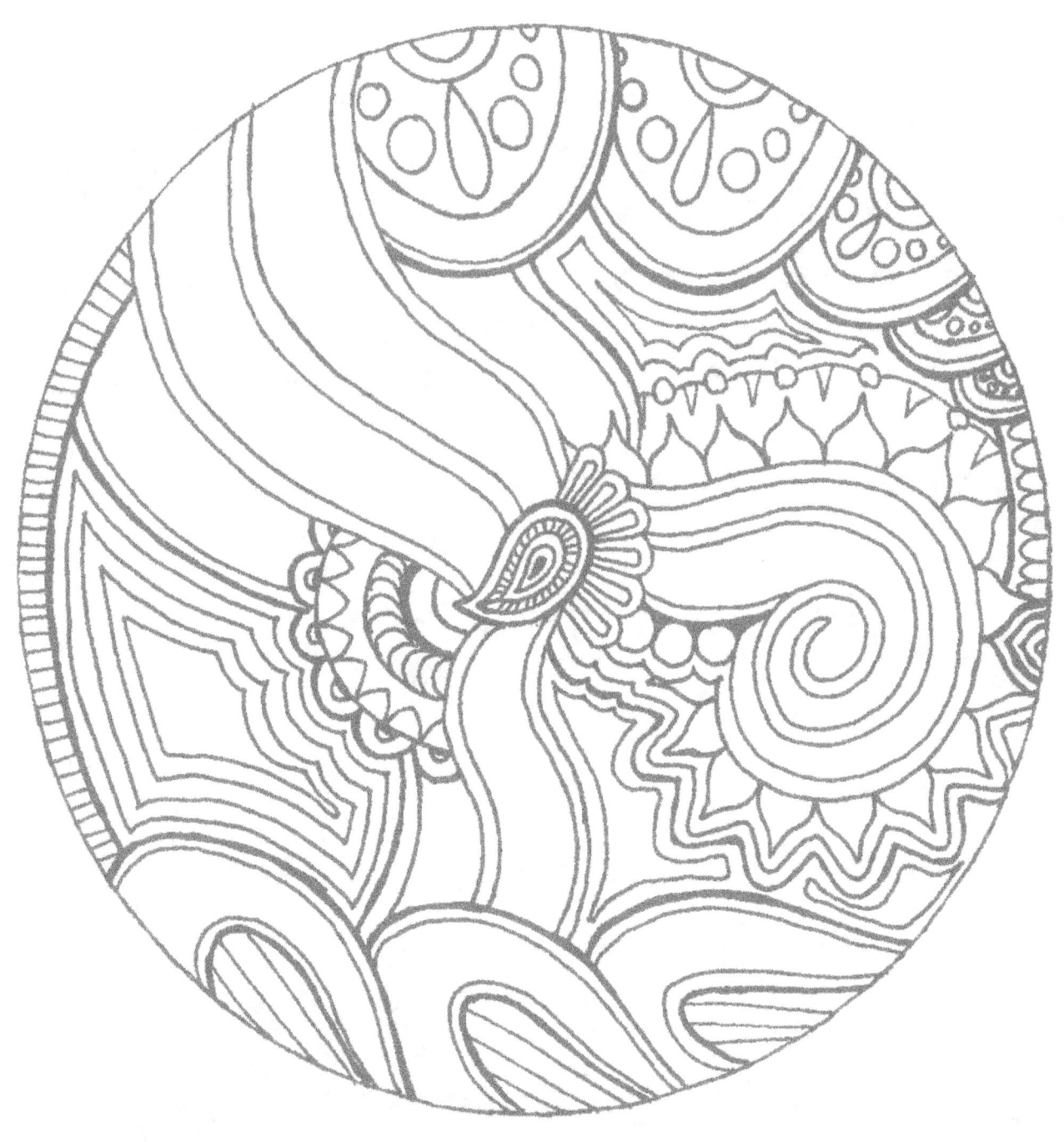

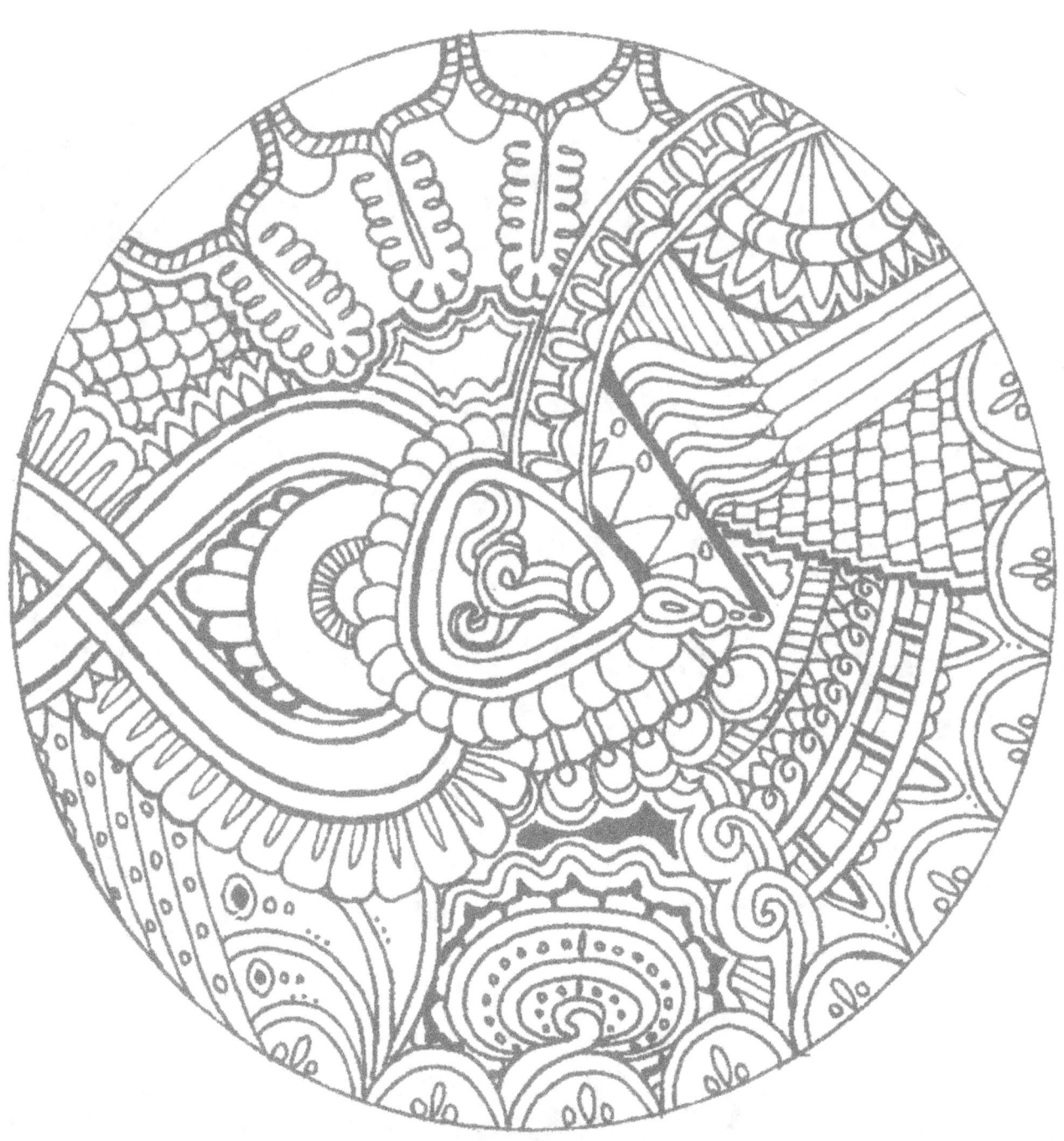

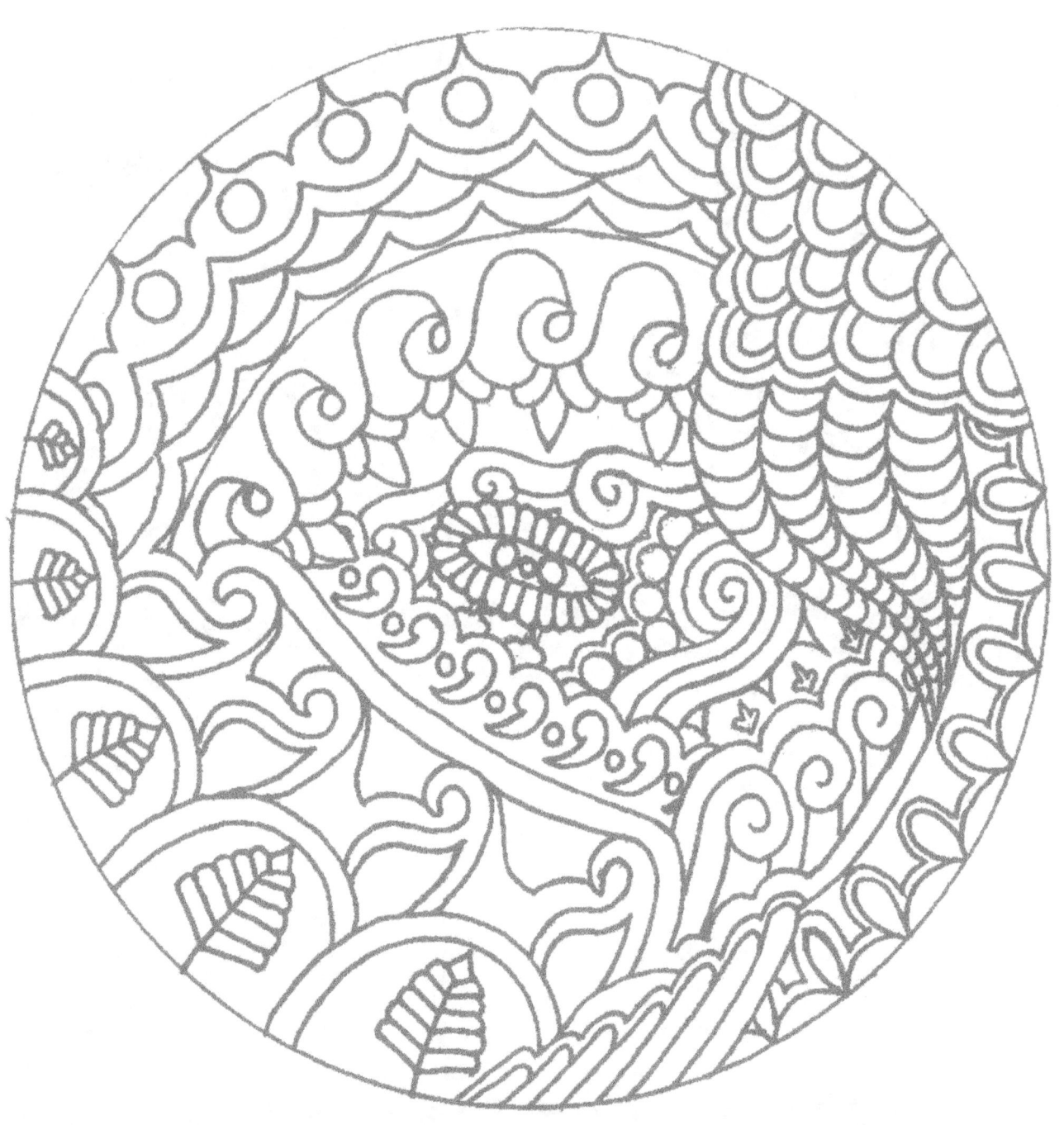

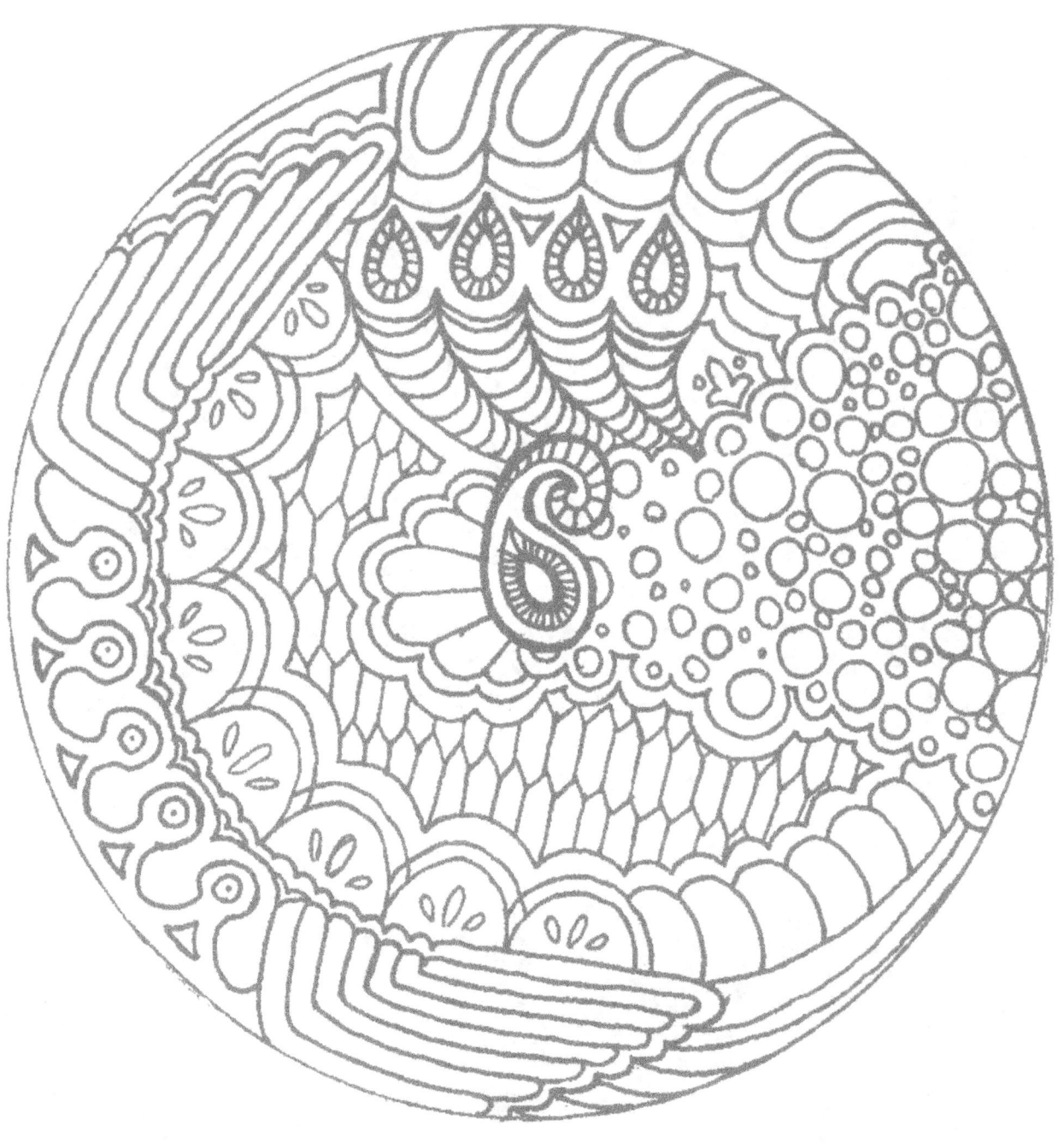

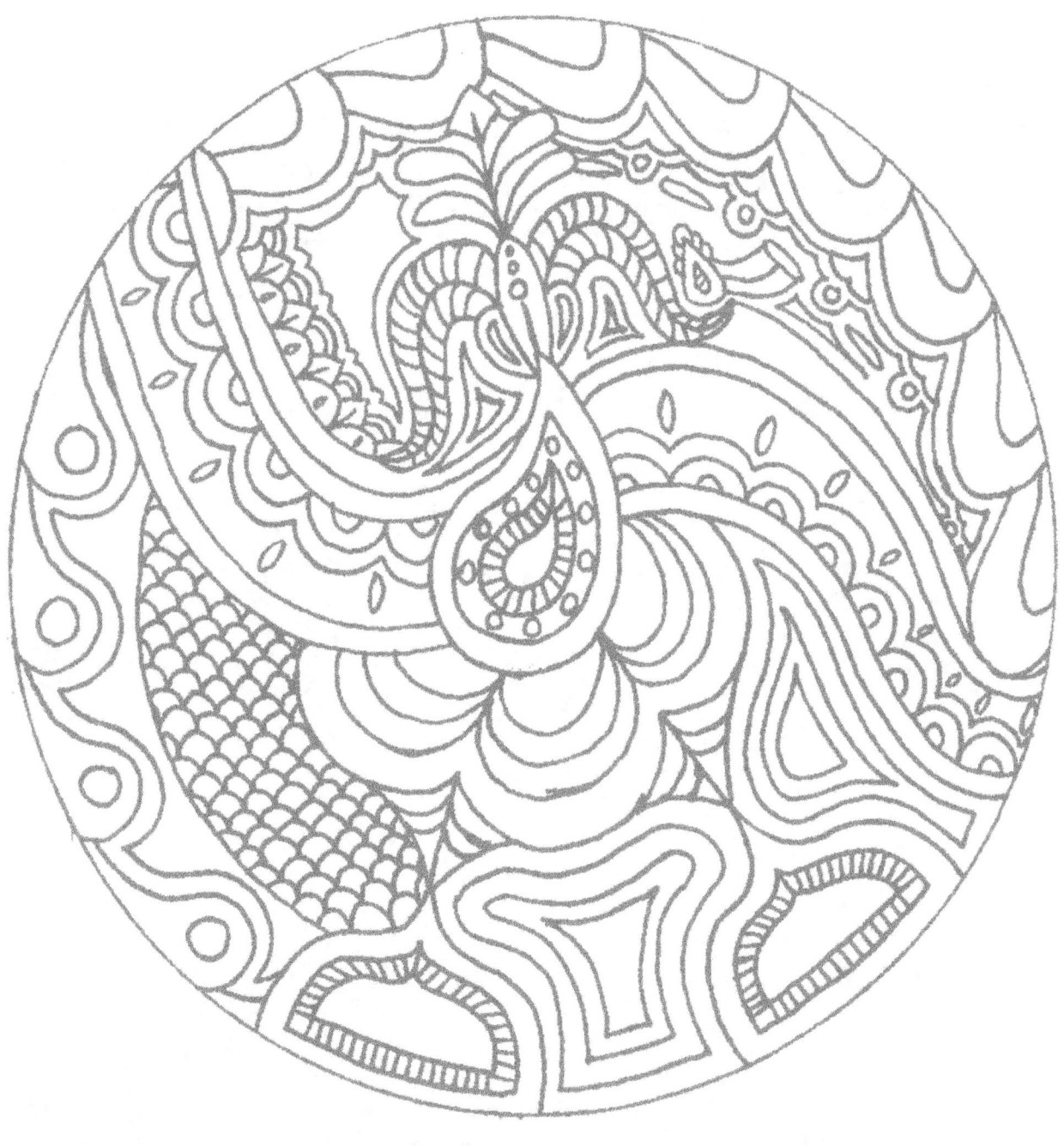

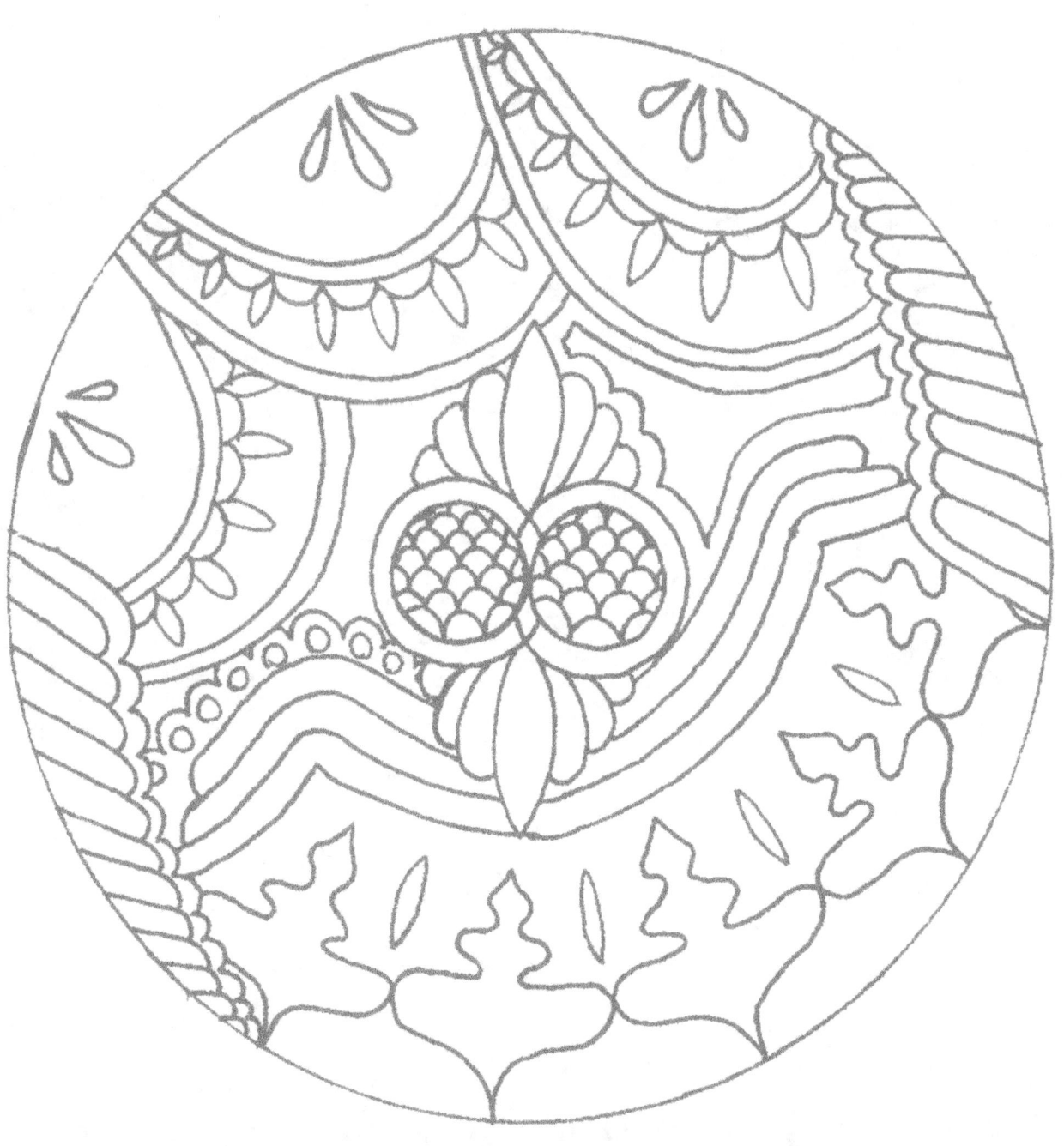

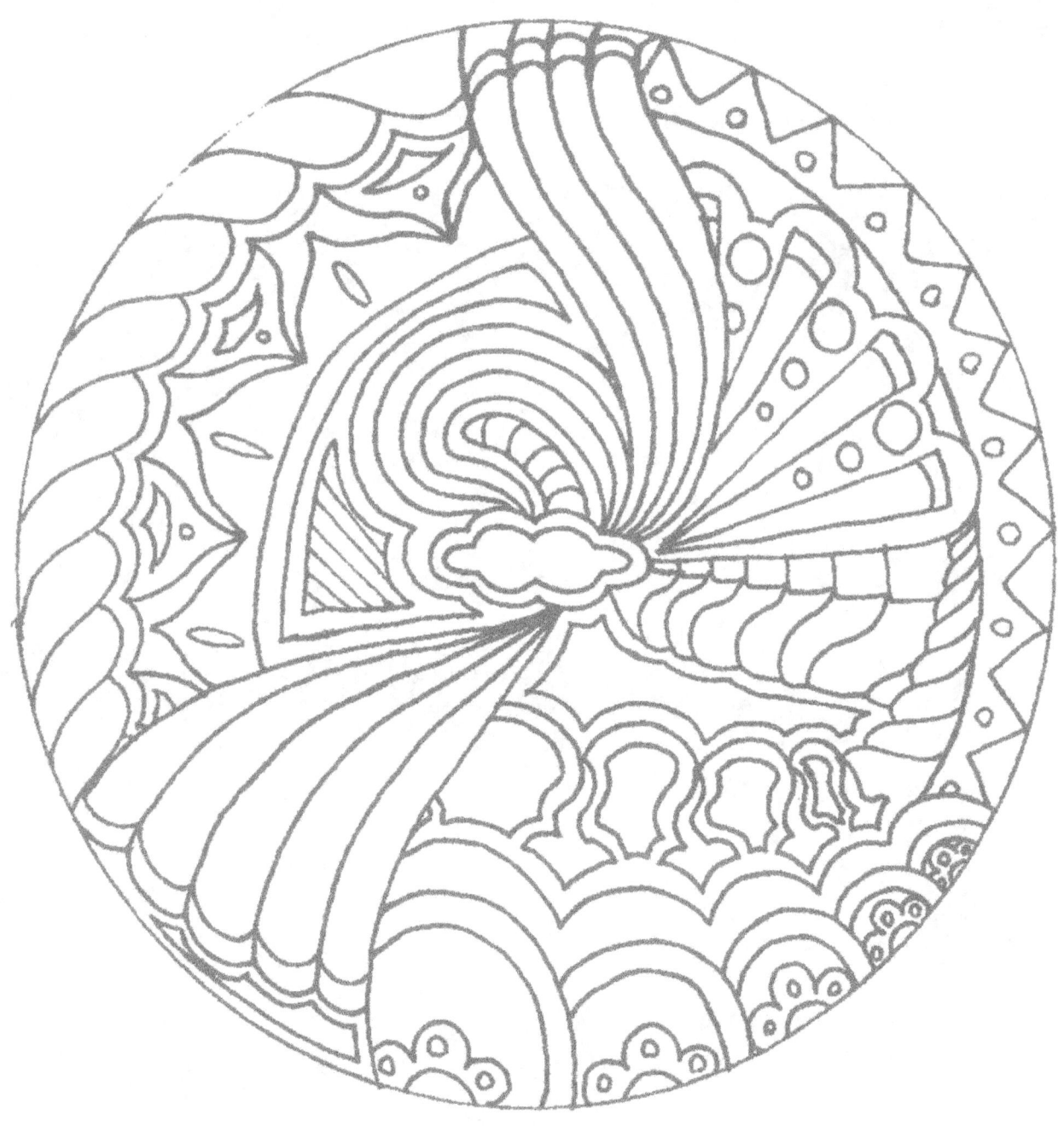

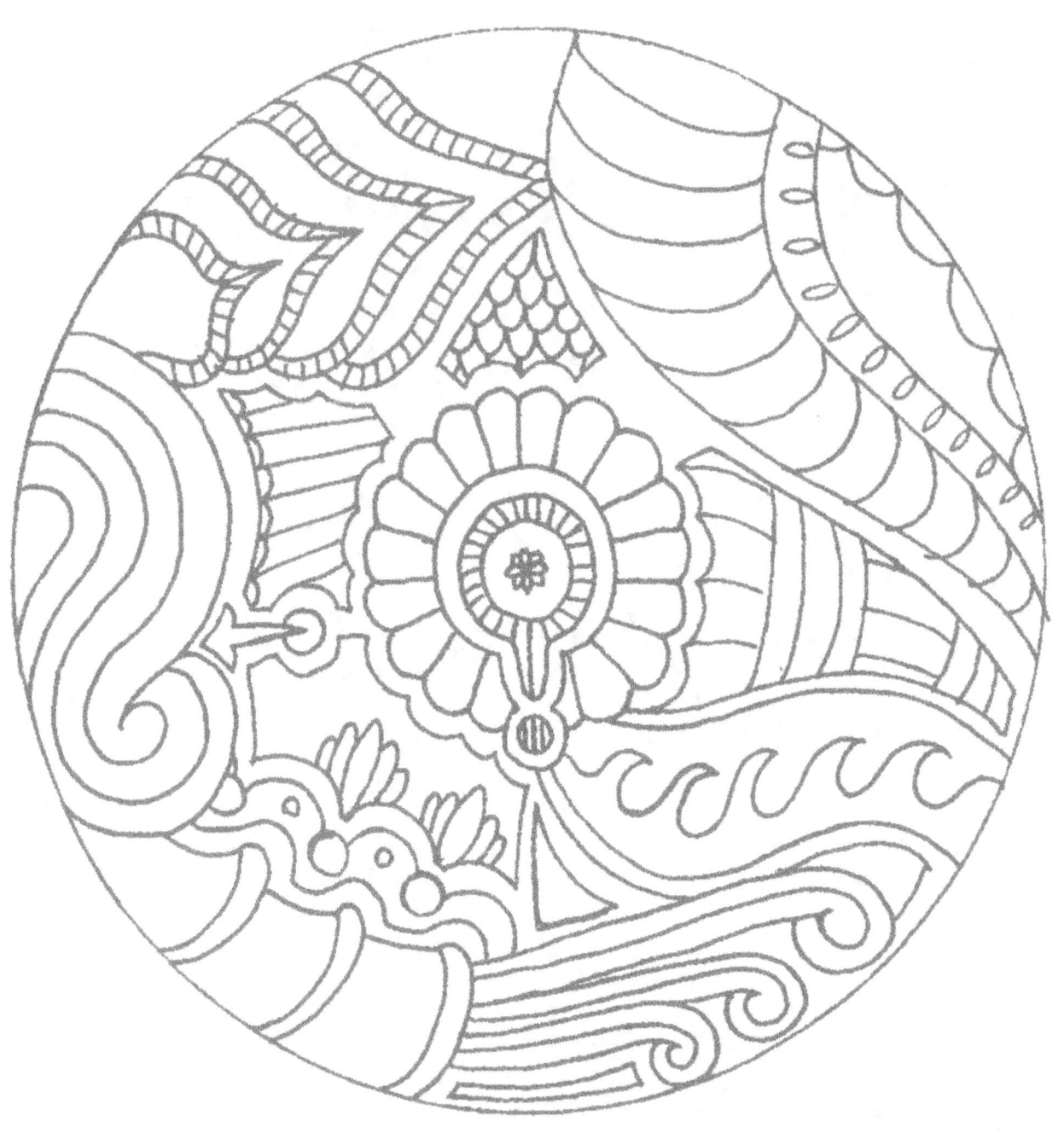

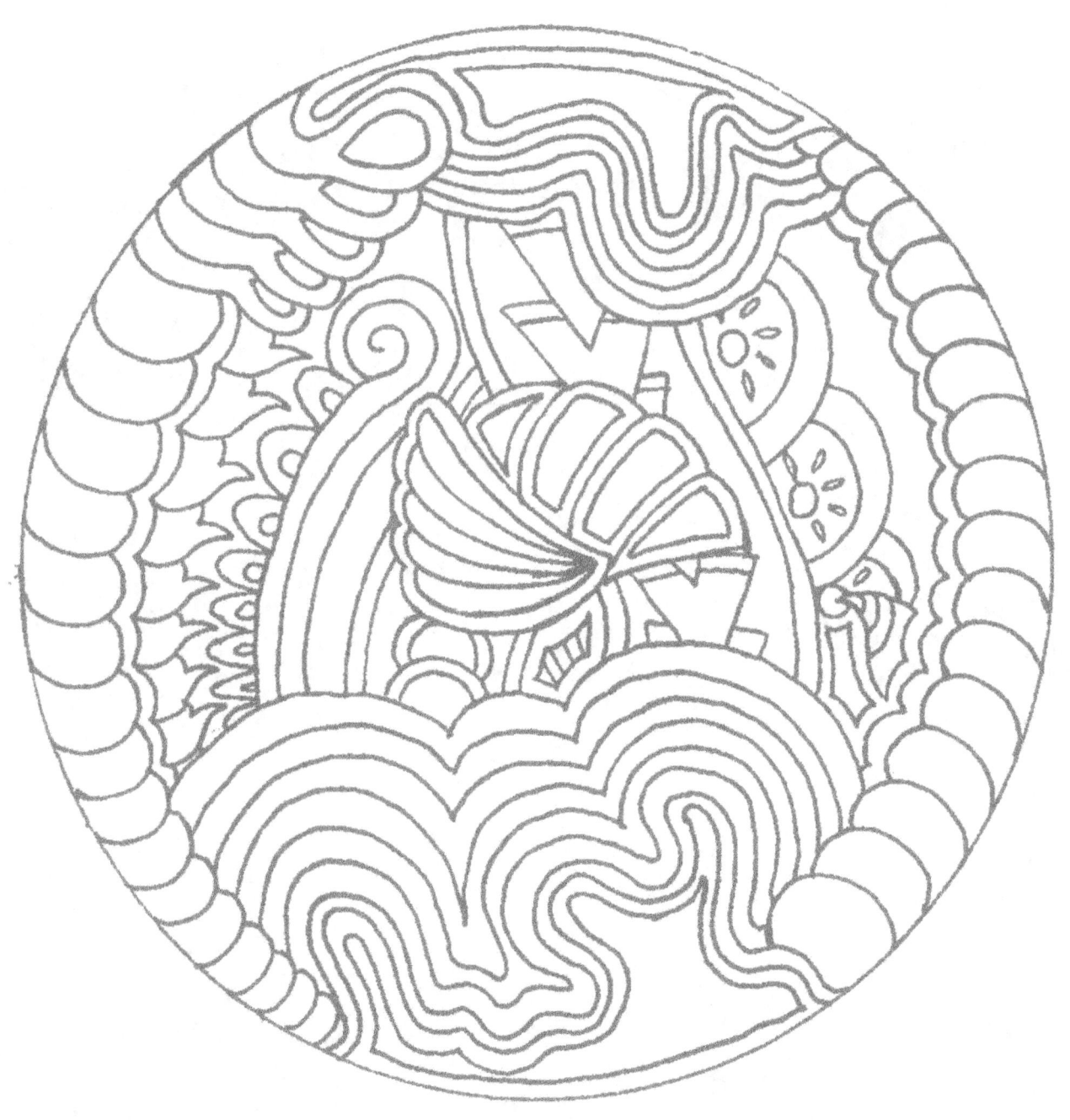

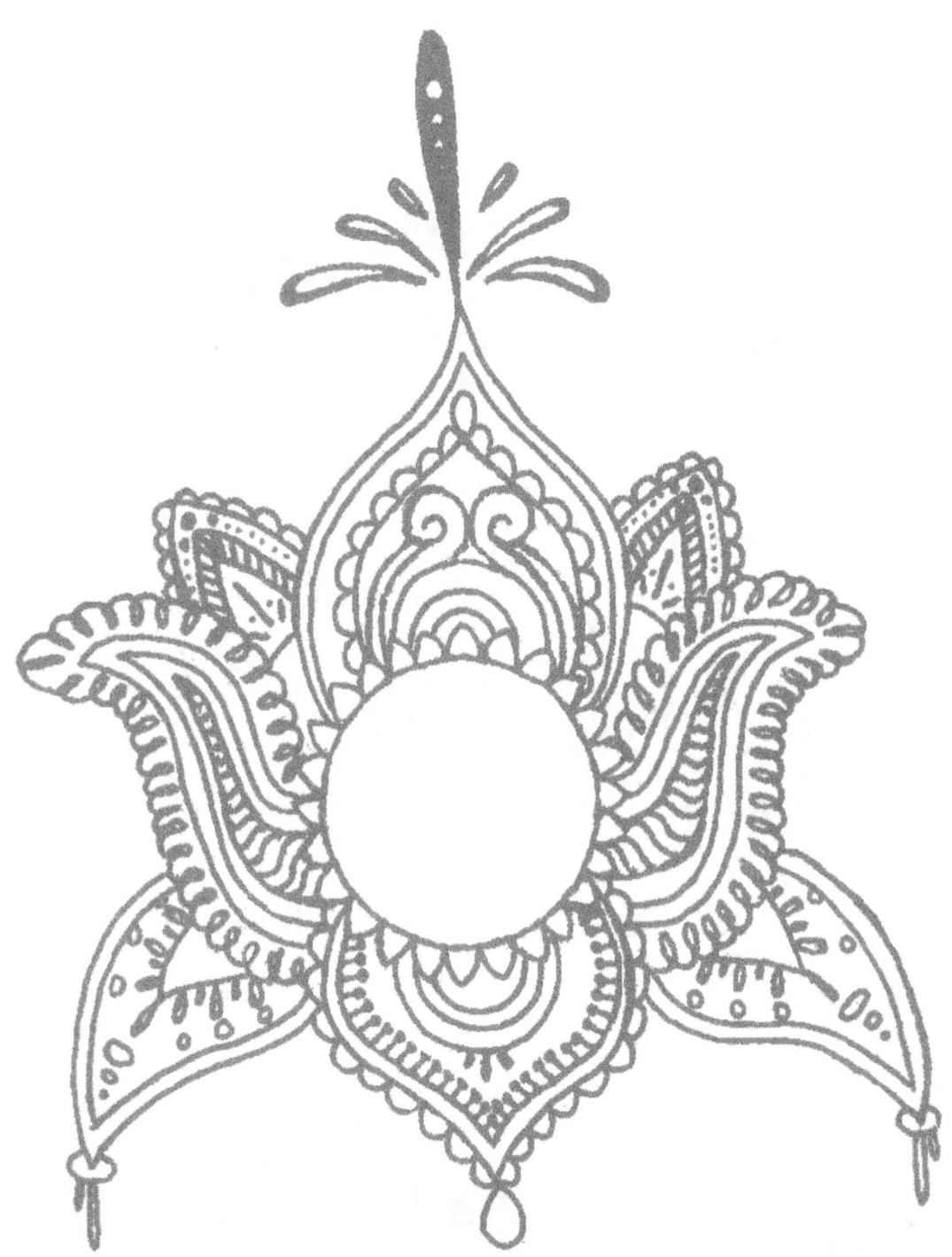

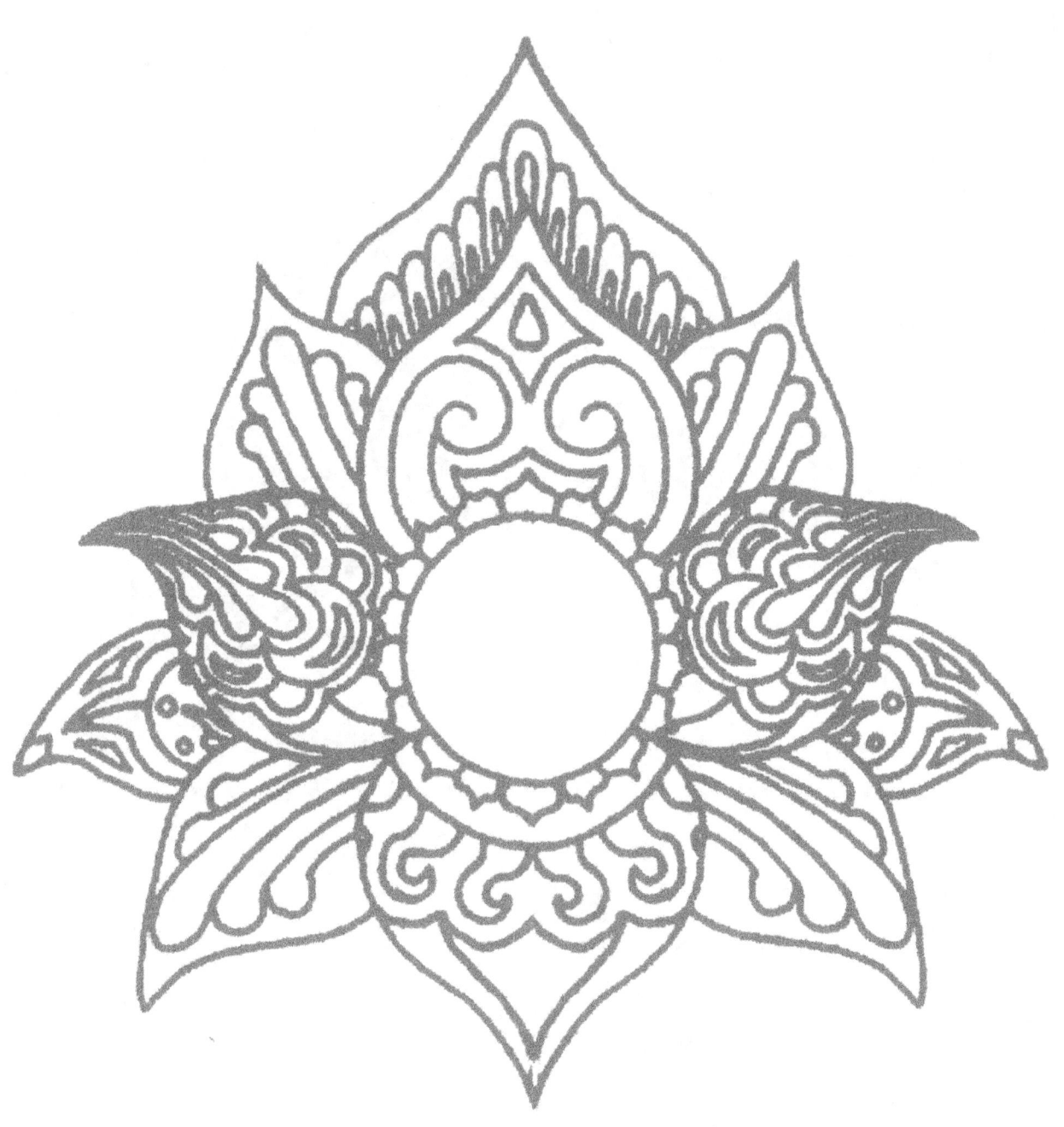

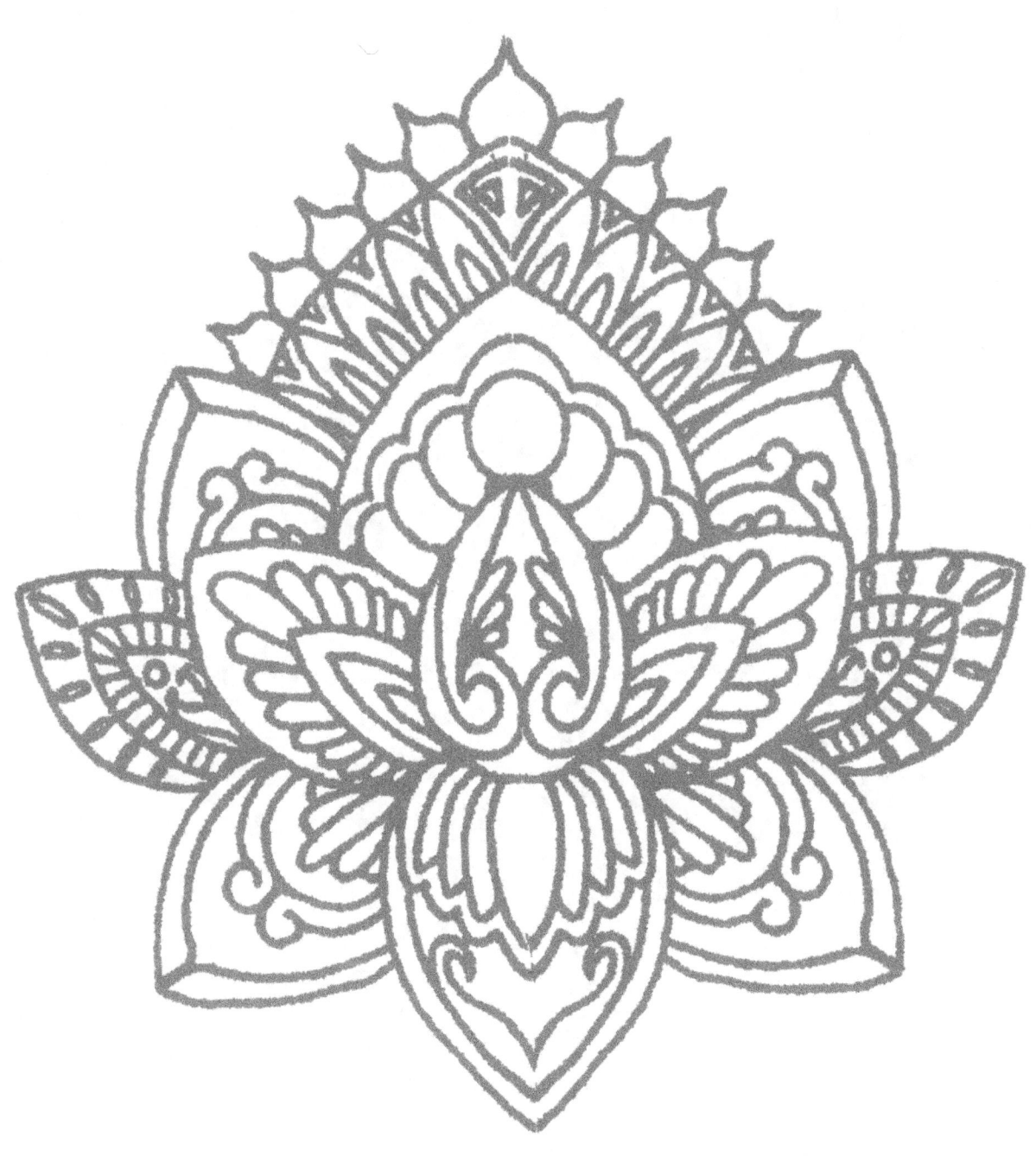

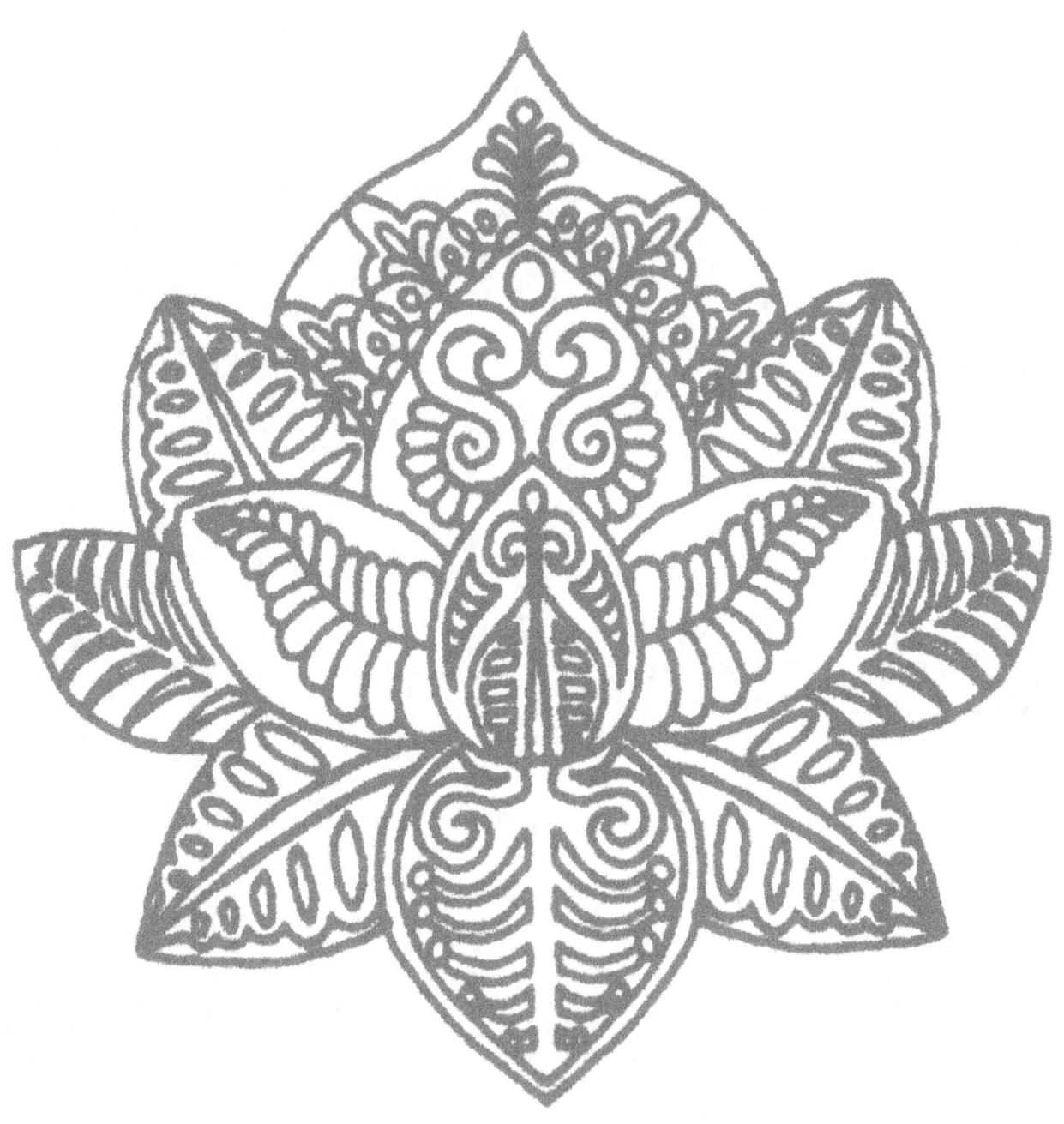

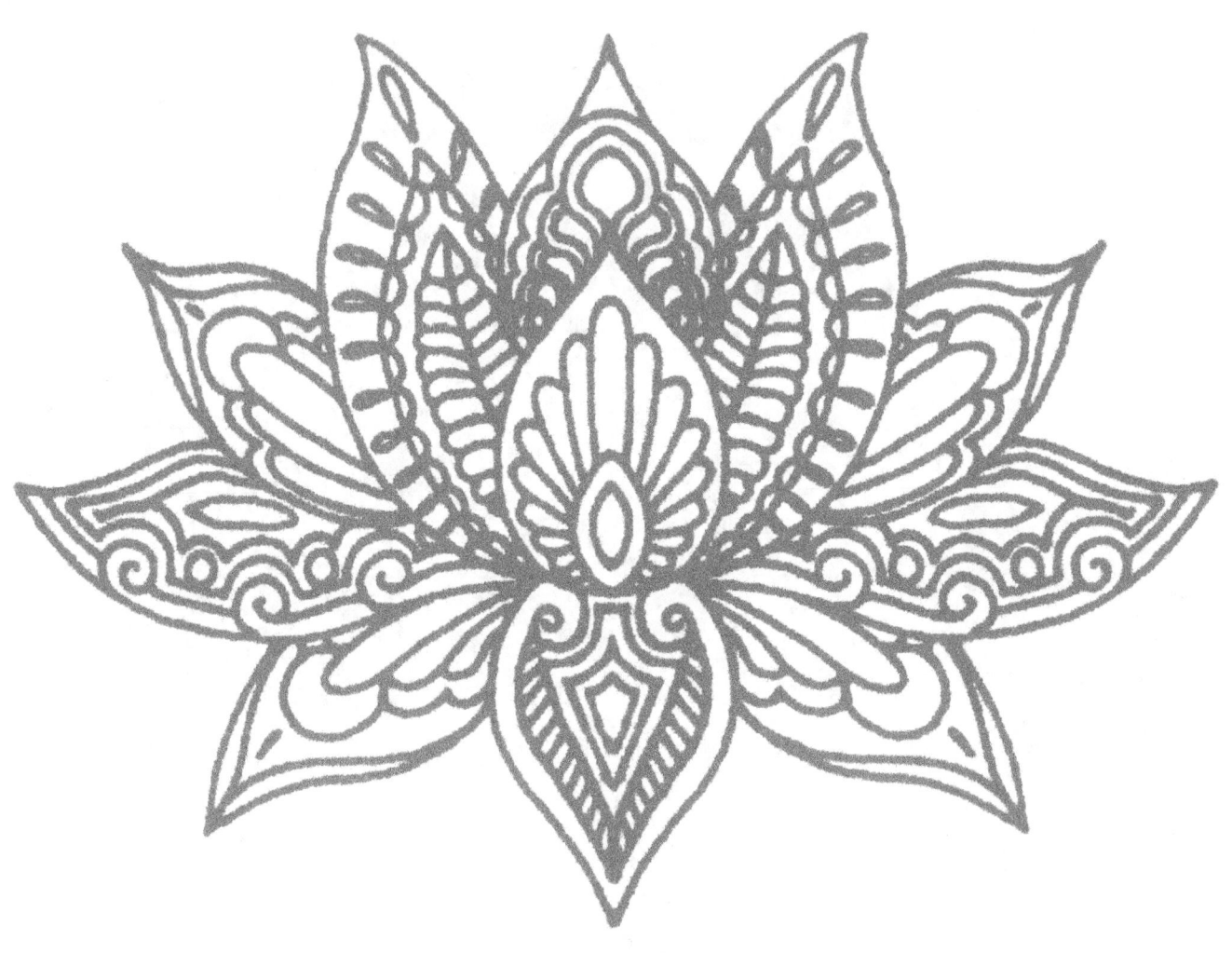

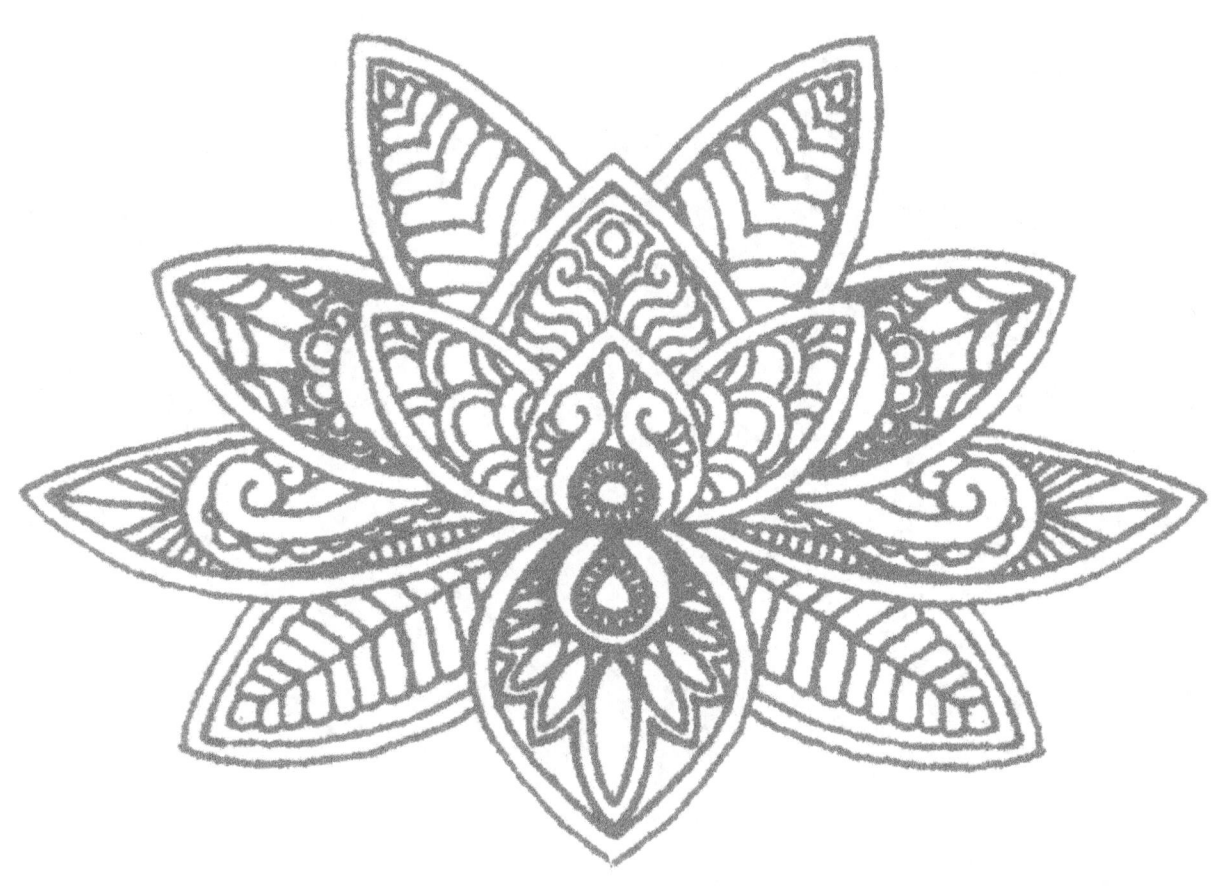

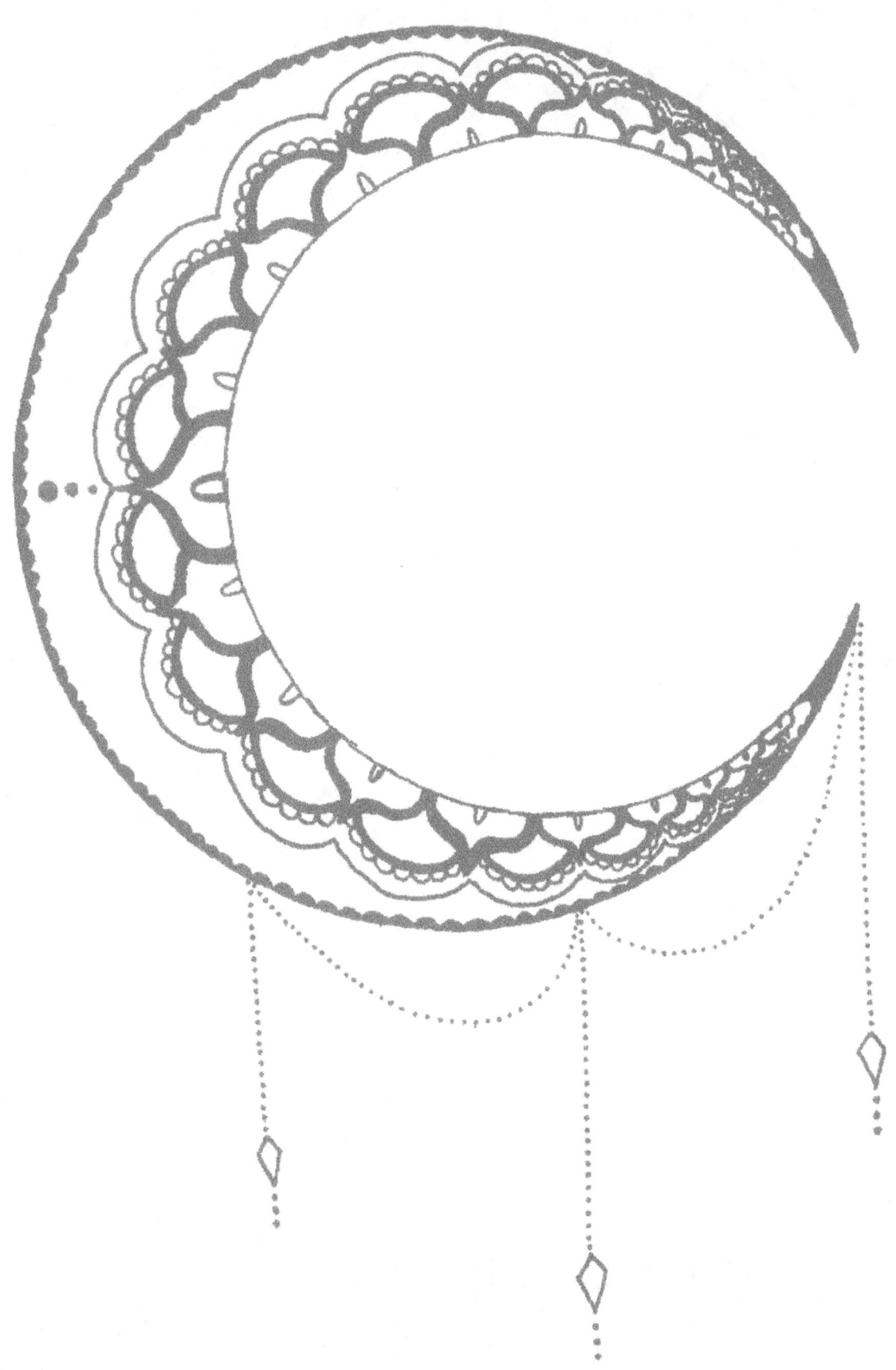

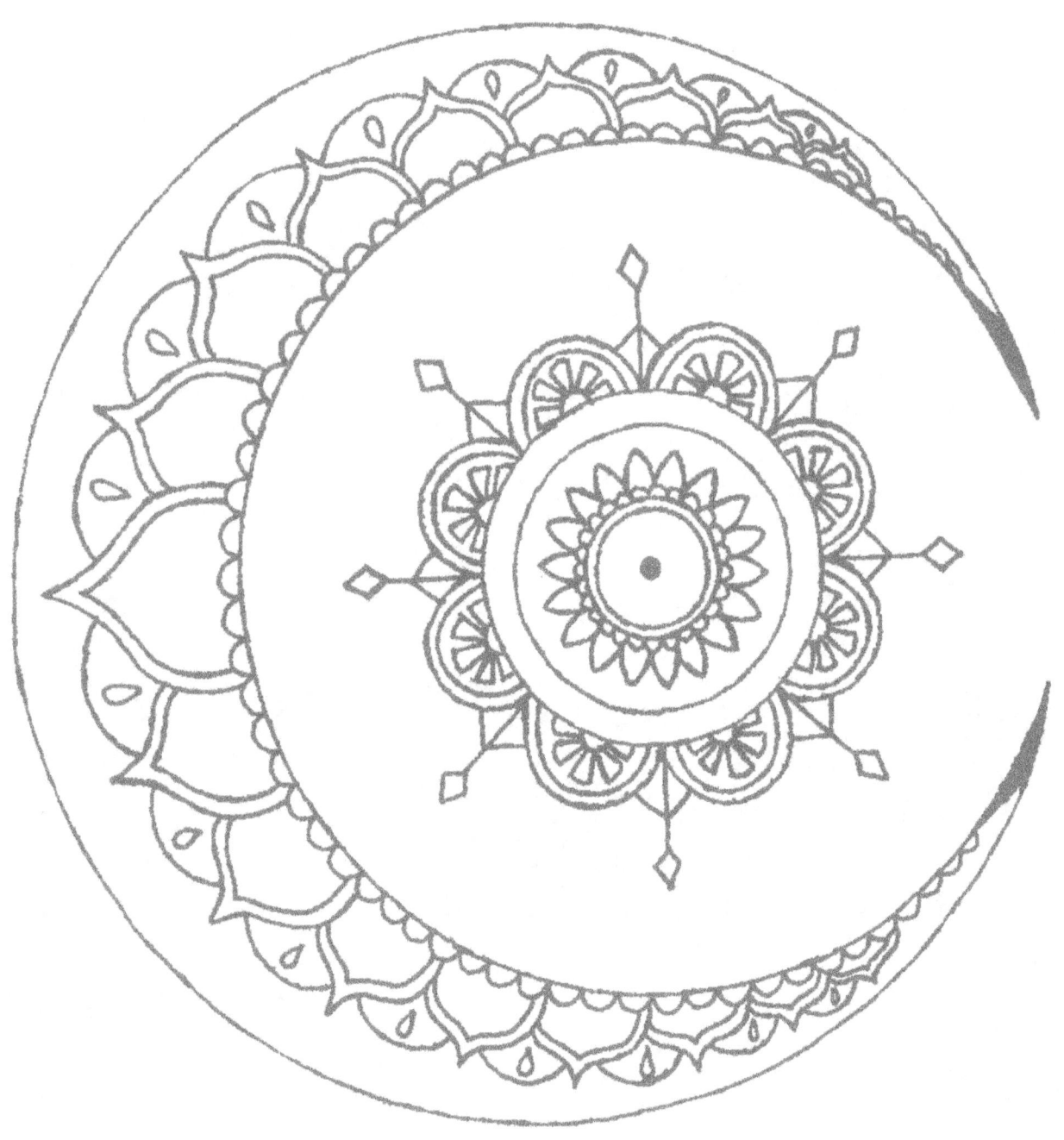

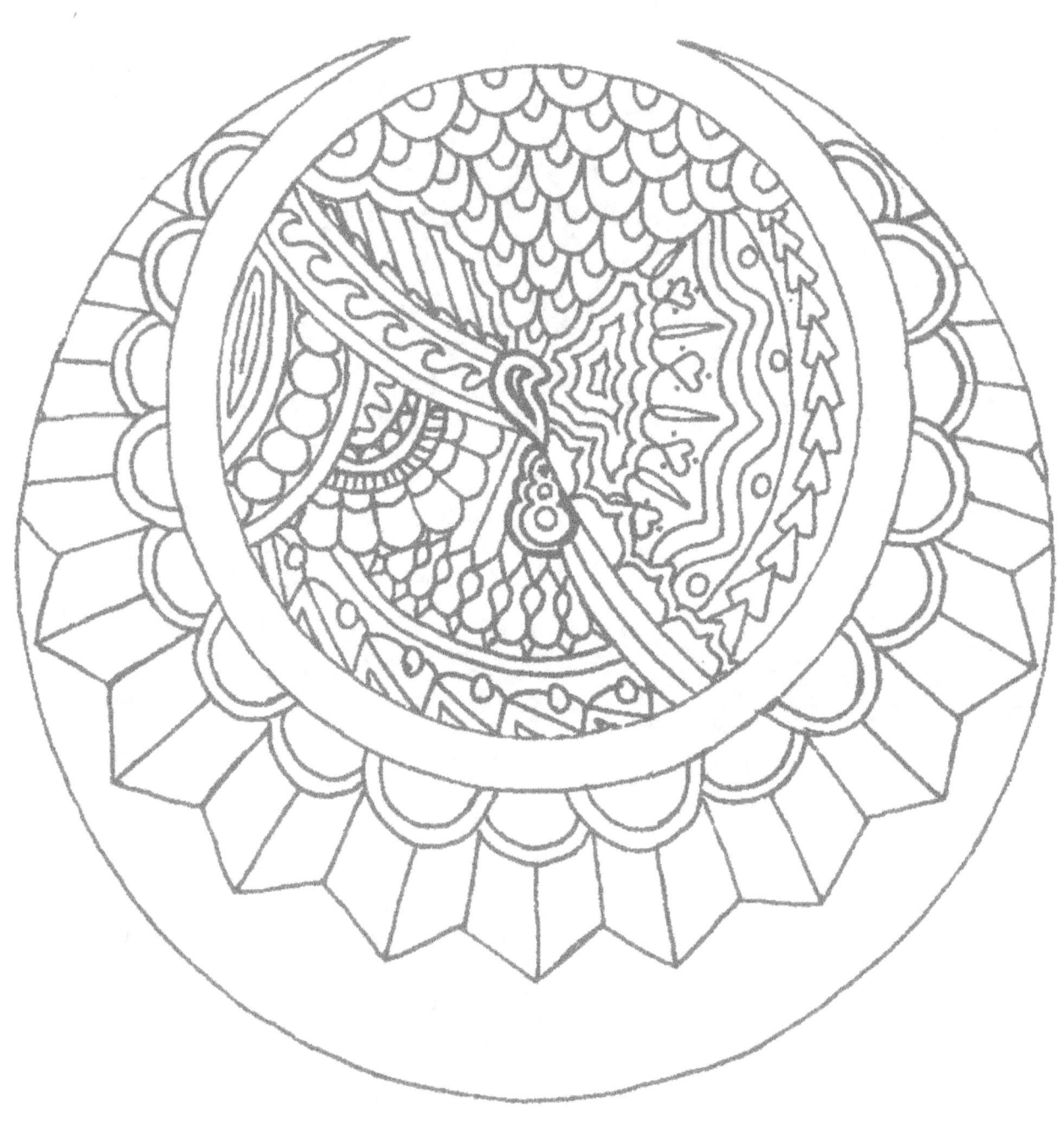

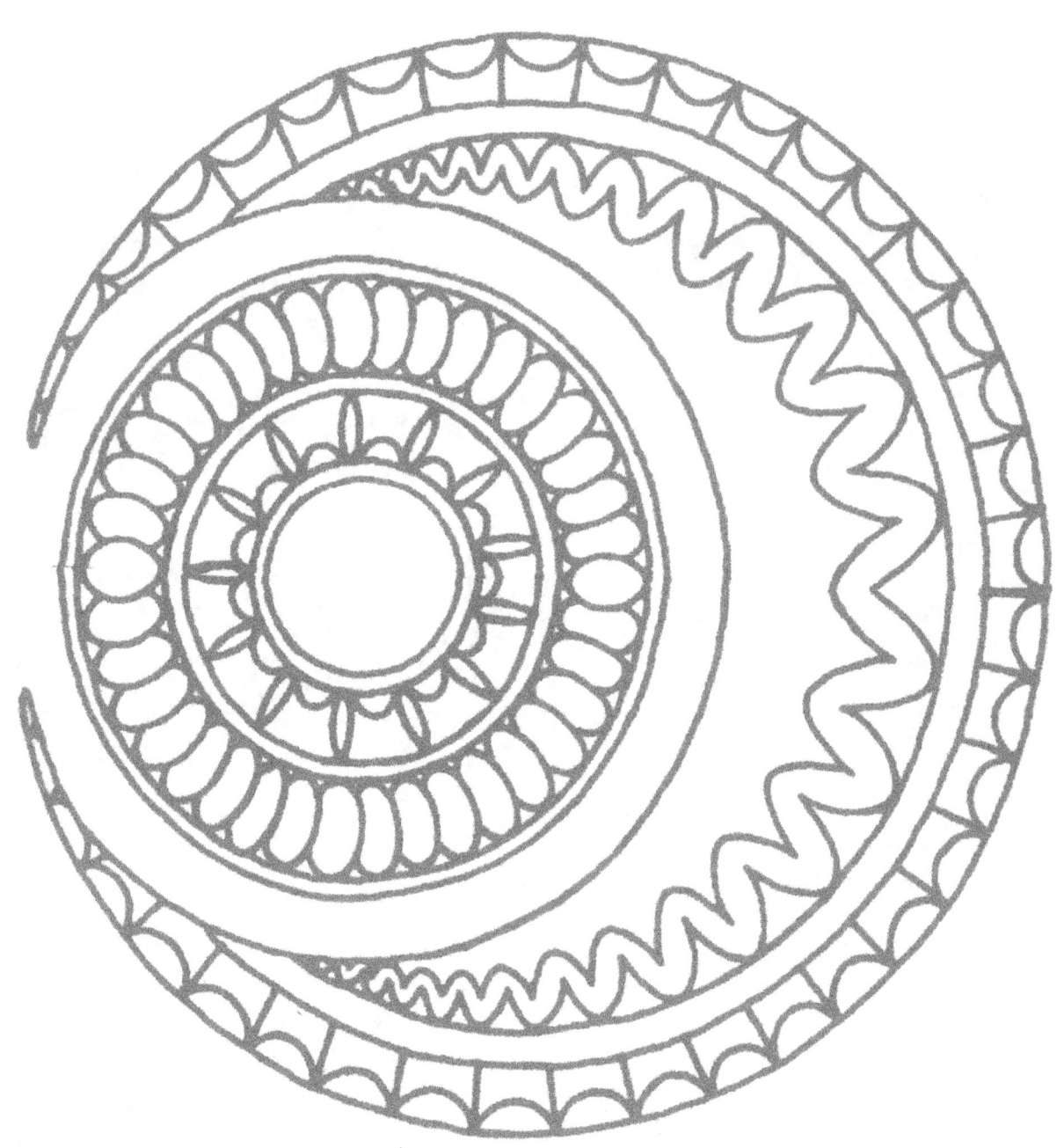

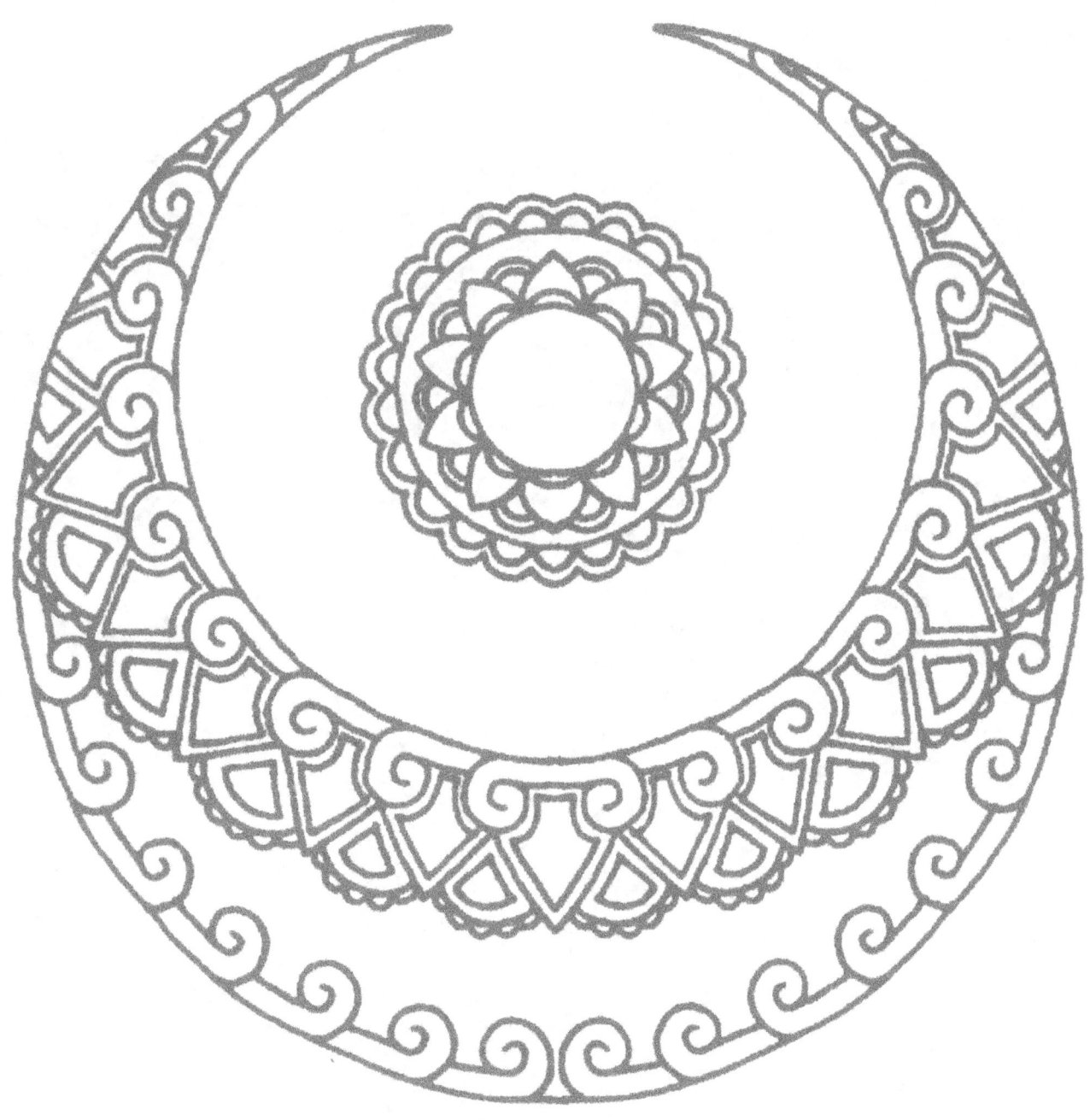

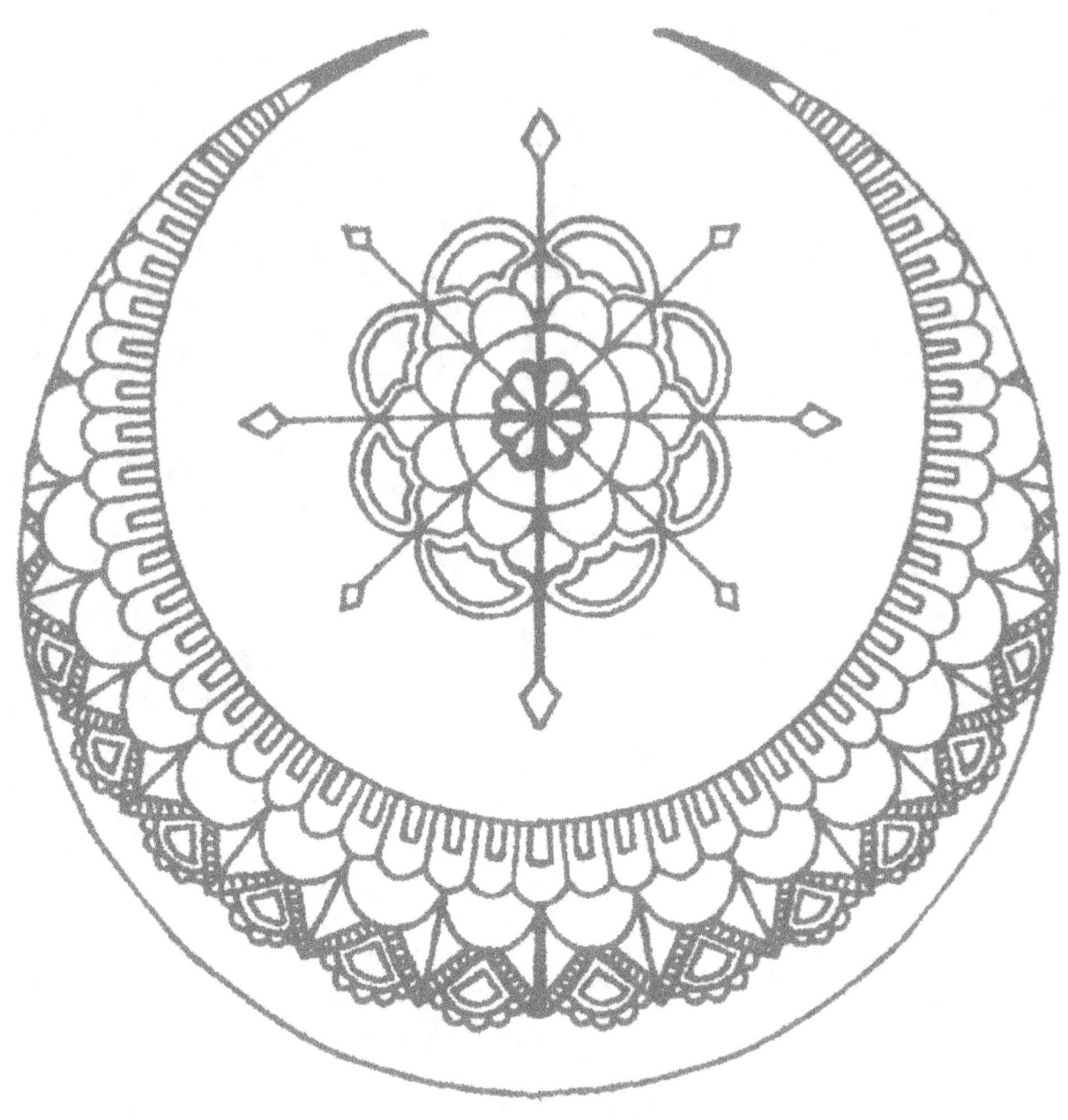

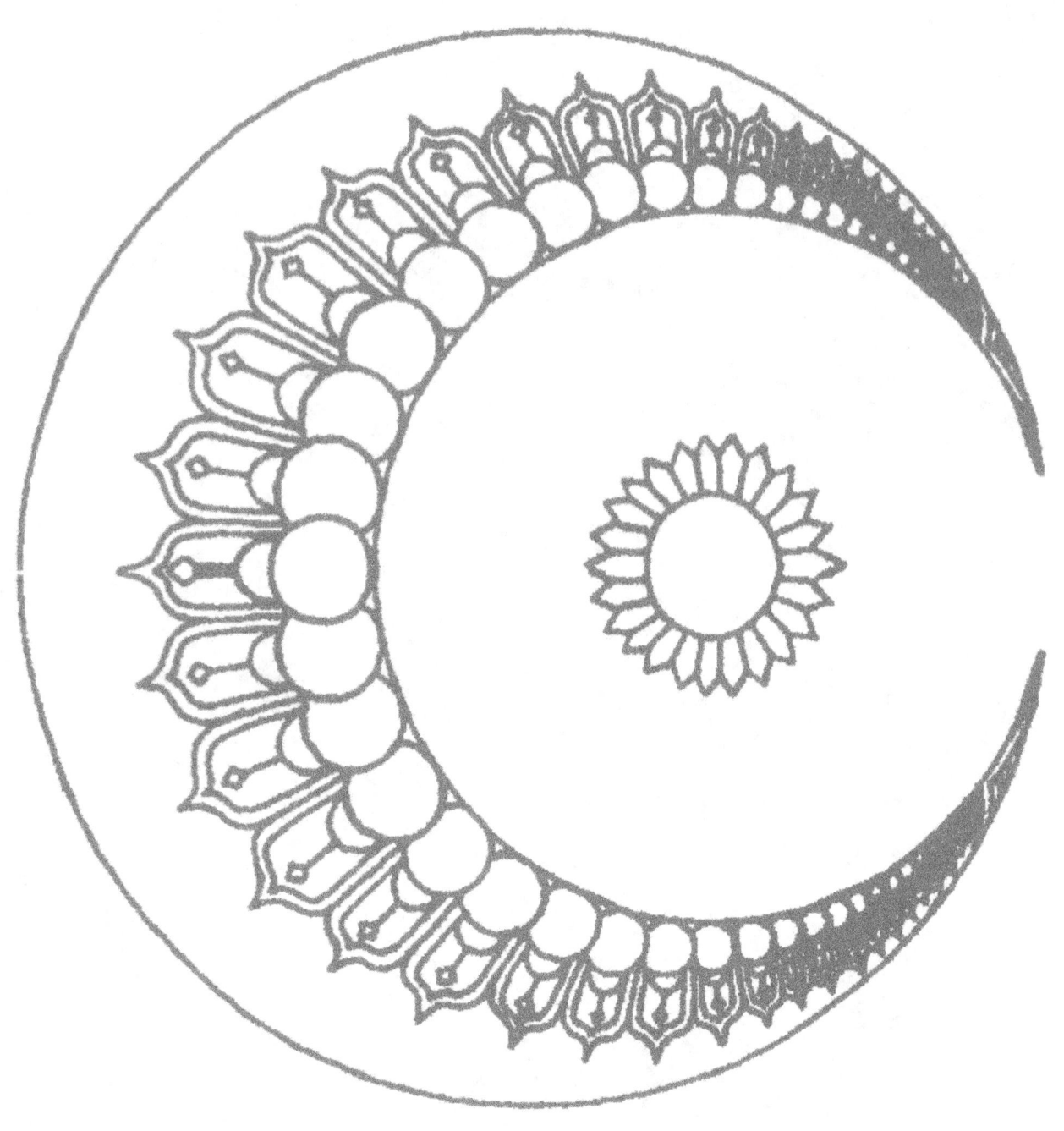

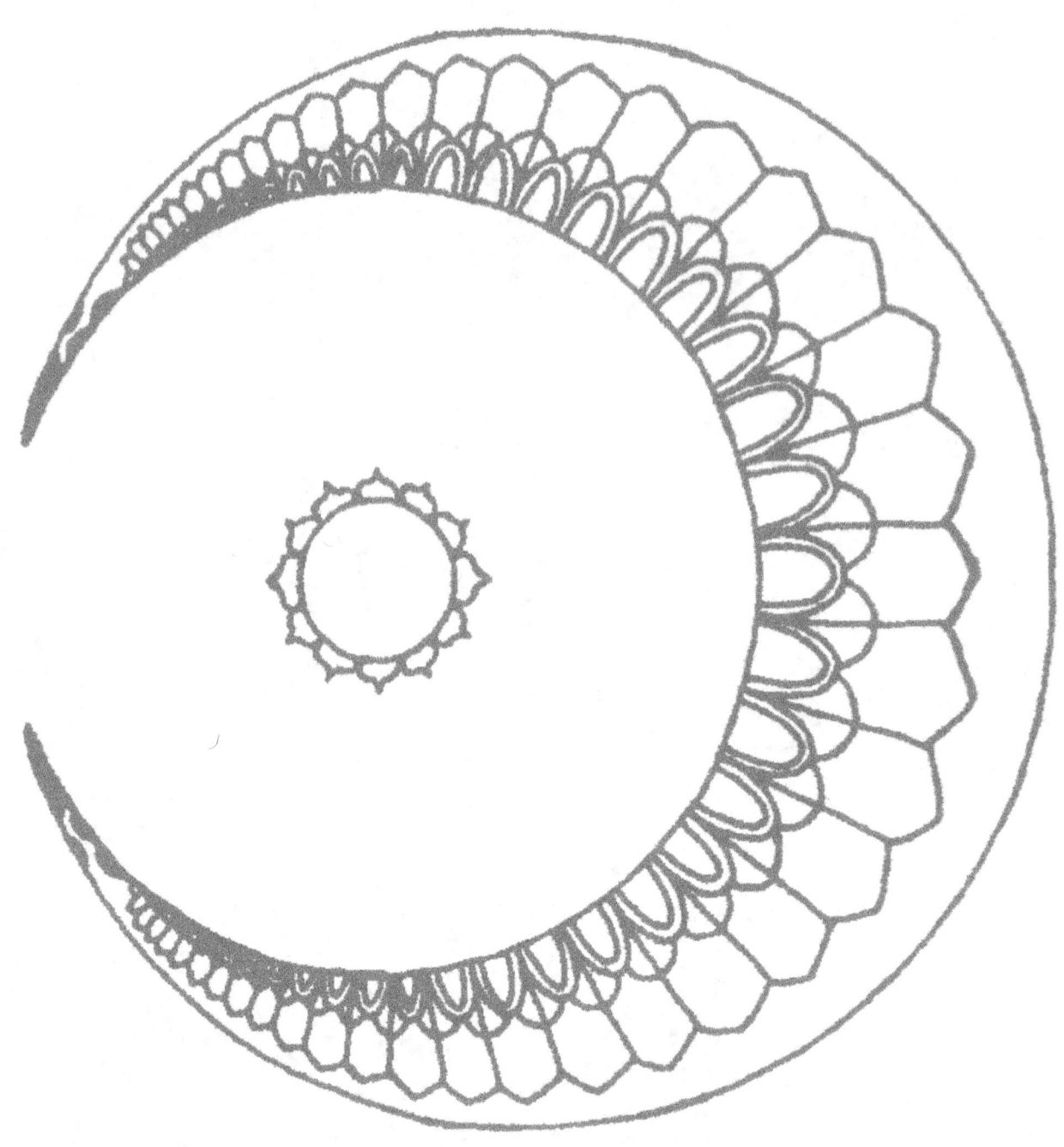

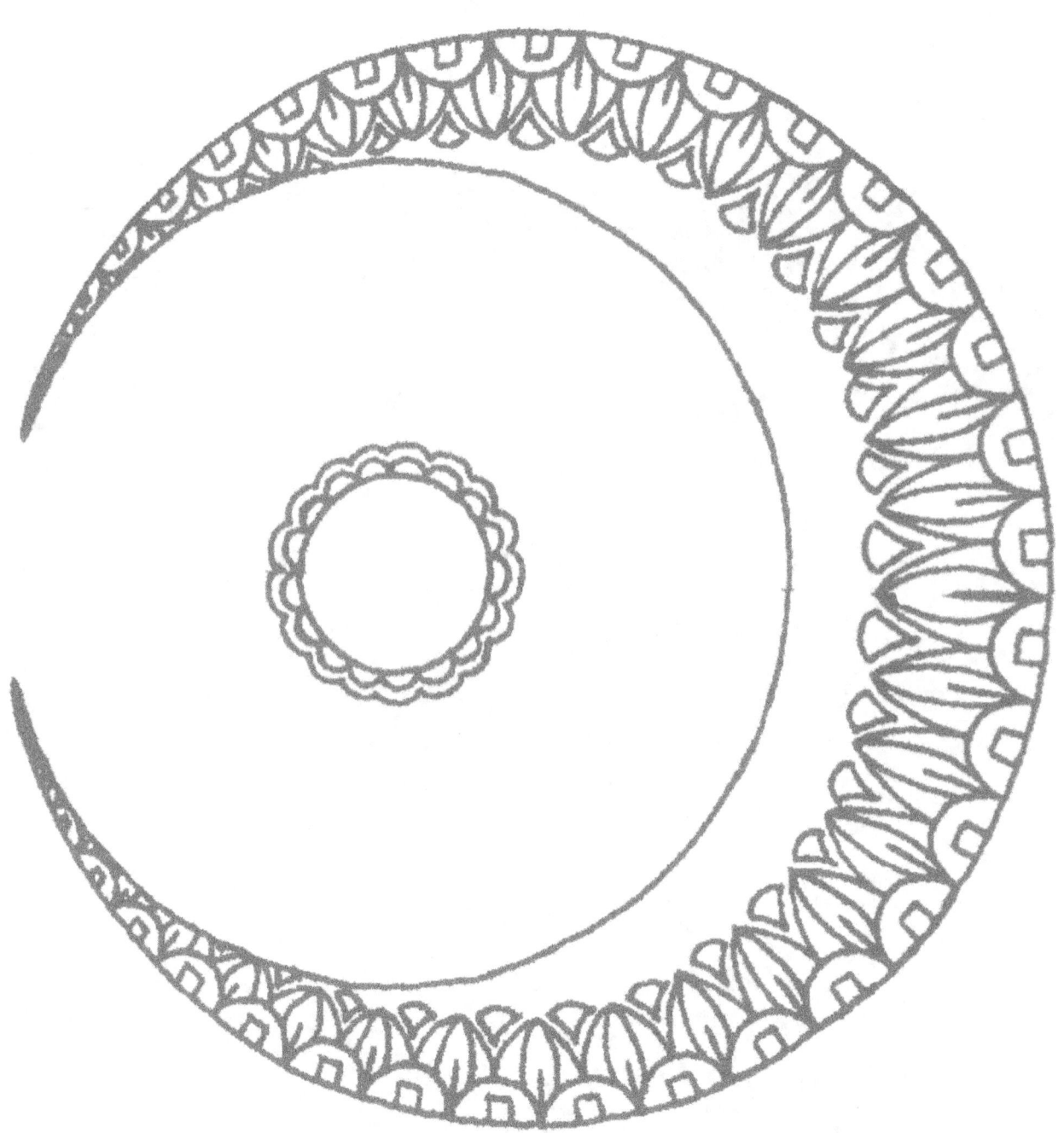

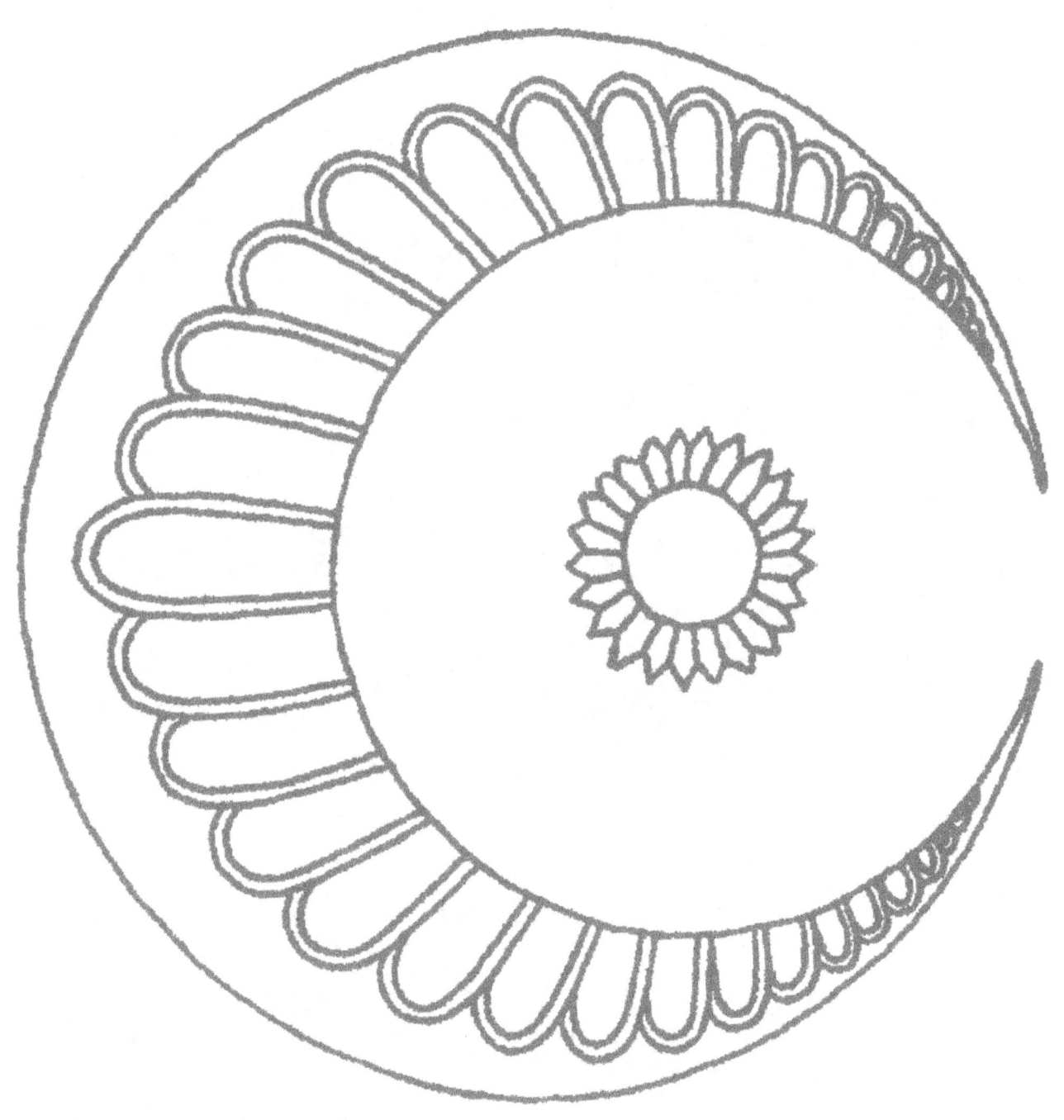

www.ingramcontent.com/pod-product-compliance
Lightning Source LLC
Chambersburg PA
CBHW080948170526
45158CB00008B/2417